Photo

CC312

£7·50

Elliott Erwitt's Handbook

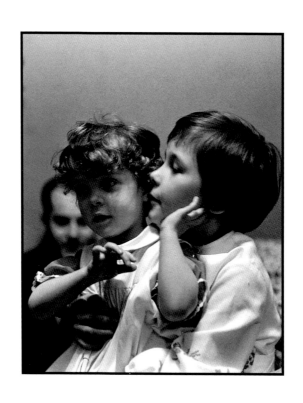

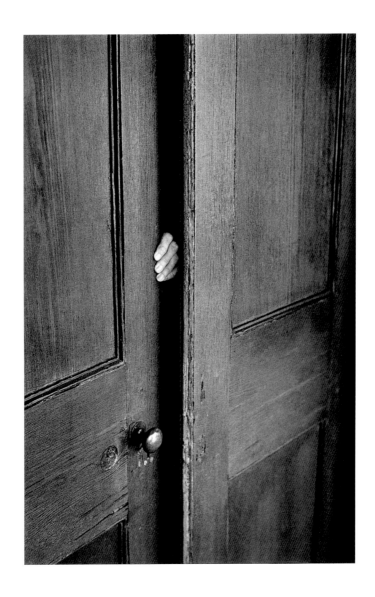

NEW YORK CITY, 1961

2

Elliott Erwitt's Handbook

FOREWORD BY
Charles Flowers

THE QUANTUCK LANE PRESS
NEW YORK

Design and typesetting by Katy Homans
Manufacturing by Mondadori Printing, Verona

ISBN 0-9714548-3-3

THE QUANTUCK LANE PRESS

Distributed to the trade by
W. W. Norton & Company, New York, N.Y. 10110 and by
W. W. Norton & Company Ltd., Castle House,
75/76 Wells Street, London W1W 3QT

1 2 3 4 5 6 7 8 9 0

PHOTOGRAPH PAGE 1: JACKSONVILLE, FLORIDA, 1968

Foreword

This collection of Elliott Erwitt's photos reflects a basic rule of portraiture: Always include hands, because they are more expressive than the face. Although we speak of the "Mona Lisa smile," painters note the "*Gioconda* pose," the crossed hands that were copied by portraitists for decades. Quintilian, the first-century Roman rhetorician, advised would-be orators to use the hands with skill, because they can "almost be said to speak."

Erwitt's famously keen eye stills, in his signature instants of caught motion, a visual babbling that we barely notice, though it is nearly incessant. According to one social anthropologist, as much as 60 per cent of all human communication anywhere in the world is non-verbal, being accomplished principally with the hands. Another scientist argues that there are 5,000 different gestures. If he's right, the 500 ritual gestures of Hindu and Buddhist dance known as *mudras* make up a classically spare, rather than flamboyant, catalogue of codified expression.

Such language is known only to insiders. In daily life, too, the hands obey cultural norms. Some of the gestures shown here will amuse a Westerner, or simply seem harmless enough, but may shock or outrage viewers from other parts of the world. As Desmond Morris explained in *Bodytalk*, some gestures are specific not just to a region but to a single country, and the dispersed human family has developed a huge and diverse repertoire of insulting and obscene hand movements. A hapless European hitchhiker was suddenly set upon and severely beaten in an African country because his upraised thumb was a coarse, explicit insult to passersby. People have been shot at borders for misinterpreting a nervous guard's hand gesture: In the Middle East the gesture for "Get on over here now" looks to Western eyes like, "Get out of here!"

Less dangerously, it is absolutely true, according to researchers who study such things, that Italians use their hands more than any other national group when speaking. The semaphore acting of Italian opera

singers, deplored in westward-lying houses, is a natural enough out-growth. Most people, according to my casual, unscientific polling, guess that the British must be at the other extreme, using their hands the least in conversation. In fact, the Japanese take that laurel.

Since conversation is social contact, from the most general to the intimate, it is natural that hands are involved in that contact. Erwitt captures them jabbing the air, caressing, grabbing, grazing. Sometimes these hands touch another or others, sometimes their owners. Watching diners in restaurants, a research team (who *are* these people?) found that speakers in Puerto Rico casually touched interlocutors or themselves an average 180 times per hour. Parisians made such hand contact an average 110 times, Londoners not at all. Poor pitiable Albion.

For surely, as *Elliott Erwitt's Handbook* affirms over and over again, we want to touch and be touched, or we wither away and die. We want to cradle an infant's head, for it is another soul in one's own hard, restrained hand. We want to be cradled, too, until the last arthritic, gaunt fetal rictus at the end of life. The untouched child, it sometimes happens, grows up unable to love or accept love. Children in this collection touch with sound and with hands. We have to imagine that they will live good lives, if these photos are accurate biopsies of the human heart.

And if we who hear realize that hands are communicating as words are spoken, how much more richly and subtly the deaf apprehend and define their worlds in gesture. Just as other babies prattle in their cribs, those who cannot hear will gibber away with their chubby digits, practicing to communicate without knowing that what they do is considered compensation by others—not compensation to them, for it suffices the need.

An odd fact: Beginning portrait artists typically sketch the hands of their subject smaller than they should be proportionally. Yet we certainly know the power and size of our own hands, which are usually as long as our face. Do we subconsciously diminish the size of a stranger's hands out of some atavistic, self-protective psychological need? Do we

experience our own hands as larger than others' for some other reason? Do we hope for longer "lifelines" in the palm?

Ask anyone how they feel about their hands. More than likely, they look quizzical for a moment, then launch into an answer that is not new-minted, for they've indeed thought about their hands often before.

"I have my mother's hands, but I wish I had my father's . . . they were wider; he had a firmer grasp."

"Women say I have unusually big hands, but I don't relate to that. But I like the scars I have . . . they're my history; they're me."

"I couldn't work without my hands, so I'm grateful for them. When I have to, I measure engineering drawings with them...first to second knuckle of my index finger is a centimeter, tip of my index finger to base of palm is 6 inches."

"They're my work. I am always conscious of not hurting my hands. I don't wear gloves when I use the electric saw because they give a false sense of security."

"The Korean manicurists say my hands are beautiful because I have extended nail beds, that pale part under the nail. Now I look at everyone's nail beds. They're right. Most people don't measure up to mine."

"I gave up playing bass fiddle because girls wouldn't go out with me. My hands got too rough and calloused."

"I have more fun with my hands than I did with my ex-wife."

"My fingers are too short, so maybe that's why I look at everyone else's fingers for flaws. Like if they're bitten or unclean, I don't want to know the person. I mean it."

"I cut my fingernails every other day. Any longer, and you look like a woman . . . and beautiful long nails, slender fingers, they're the first thing I look for in a woman."

It is well said that the face of our maturity is the face we deserve. Perhaps it is even true. Perhaps the wise gain serenity within the mask of wrinkles, the vile look haunted. Certainly, and less spiritually, each of us has the hands we've earned—cooking burns, smashed thumbs, soft fingers, nicotine-stained nails, barked knuckles, tattooed palms, rope burns, a frozen thumb, a paper cut. . . .

So the hands tell our stories, suggest character, mark achievements, record a family.

You will not forget, or have not forgotten, the first time you look down and suddenly see—calloused or liver-spotted, wrinkled or scabrous or contracted—the hands you knew long before in childhood as the hands of an older relative. My hands now look like my grandfather's hands in the year he went mad. Your hands mark the decades, of course, but also bring you home to your heritage, and you can rue or celebrate, but you are there. The fix is in. The hands can betray the age of the face, as we see on page 33 and often enough in real life. But the hands can create the face, or a version of it, as on page 60.

But in the practical world, as Aristotle wrote, the hand "is the tool of tools." And the first of our hominid ancestors sophisticated enough to be included in the genus *Homo* was named for using his hands to make tools: *Homo habilis*, "the handyman". It is this skill, with a few scattered limited exceptions in nature, that still distinguishes us from the rest of Earth's pawing, gnawing fauna.

It was probably long after we at last became *Homo sapiens* that we learned to count by using our fingers. For that reason, the counting system that dominated the world until the binary system of the Computer Age has a base of 10, although other ancient systems worked well. The Greeks and Romans chose the basic physical tool of the mortal human hand as the key to understanding the clear cool abstract immutable laws of math, arithmetic to calculus.

But it is less the hand's role to inspire theorems than to act in the physical world where it can make, build, create, or destroy, steal, betray. Since we are symmetrical beings, we have looked at our hands in action over the generations and balanced human good with evil: In many cultures the right hand is believed to be primary and benign, the left to be secondary or malign. As is often noted, "sinister" derives from sinistra, the Latin word for "left" or "on the left hand." Yet each hand, left or right, is an equally astonishing mechanical device, the skeleton's most flexible part, assigned twenty-seven

purpose-built bones and the nineteen muscles that manipulate and govern them.

Handedness, the subject of much discussion of the politically correct variety, is anatomically easy to describe—the righthanded person's handedness is dominated by the left side of the brain, and vice versa—but still mysterious. Allowed their own preferences voluntary or involuntary, most people of either handedness get along much the same way in an active life. Baseball, the sport that is America, provides an exception: There are no lefthanded shortstops playing in the big leagues. They'd be run over before they could launch the throw. (Try it.) Another exception is Aurora teetering elegantly *en pointe* in the Rose Adagio in *The Sleeping Beauty*. If one of those princelings incorrectly thrust out his left hand when she needed to drop her hand and steady herself, the ethereal dancer would collapse in a heap on the planks of a shuddering stage.

But in almost every activity the hand of one's choice can capably punch, embroider, scratch, arouse, pilfer, steer, tickle, sketch, clasp, smack, plink, snap, goose, input, strangle . . . and all the rest.

For all of these reasons and because of his own sensibilities, Erwitt's photos of hands are photos of character, of feeling and discourse, of life in flow guided or articulated by gesture. Although his humor is sly and his images witty in composition, his work comes down to love of humanity and of the beauty of life in its homeliest forms. Even the lords of politics and celebrity who appear here are seen as our fellows, as members of the natural human democracy.

On page 86 the great cellist Pablo Casals is working with his volcanic hands, a craftsman producing the mathematical abstractions of baroque music, but also an aging man regarding the arthritis that has become his enemy. The adjacent photo shows Casals again, face turned away from us and head bowed slightly, the world-famous genius of performance now a man alone with his wife Martita, whose smaller fluted hands gently rearrange his neckwear. His hands, her hands . . . he, she

. . . For Erwitt, who believes more than anything in the likelihood of love between man and woman, the hands here help reveal who the people are and how they feel.

As I've noted elsewhere, Erwitt does not like hoity-toity, artsy scribbling about his photos. That's neither *faux naivete* nor an inability to recognize aesthetic issues. Rather it is his choice to engage the viewer as human being without reference to trends, techniques, or historical elements in photography. In a sense, the less one knows about such things, the more immediate will be the response to the story of his kind of photo.

Some critics would diss the lack of aesthetic education in the crowd at a museum opening of Erwitt's work in New York or Tokyo, Paris or Madrid, since each untutored individual will enjoy, quoting Immanuel Kant, an "autonomous aesthetic experience." But, though he would never use such lingo, Erwitt prefers his viewer to have just that experience. He wants no screen of preconceptions between you and the photo.

He wants you to see the split-second captured by light and sense, not the art.

For you cannot rehearse the insight of pages 22–23 against pages 24–25. In the exuberance of the first two photos, the hands splay, fingers stretched outward out of control. In the grim discipline of the two-page spread that follows, the hand becomes glove-like, the fingers curtailed. (It is an anatomical singularity that the fingers can work either separately or as a block.) Even though some of these Chinese children have not yet lost their sense of humor, and the hands are not all aligned, the future is clear.

Sometimes, what Hollywood calls "back story" affects our reaction to a photo here. If you don't know anything about J. Edgar Hoover, page 100 shows a nondescript middle-aged man proffering a diffident wave. If you do know, you might be chilled by that idle gesture of the man who held Presidents hostage to his policies by means of his secret files about their personal lives.

If you didn't know that DeGaulle on page 103 was still arrogantly in charge of France and her collapsing empire, you might see only an

old man awkwardly saluting as he recalls his heroic youth on some sort of memorial day. It is the truth of Erwitt's eye that, even if you do know the former, you immediately witness the latter.

In the marvel of our hands, say these photos, there are powers and wonders. To many, divinity works through them in all ages to heal the sick, to stop the Old Testament sun in its course for a day, to bless Akhenaton's people in ancient Egypt, to protect those who are true believers in Buddhism.

In these more secular images, Erwitt shows that humanity, too, works through the hands. Each time you return to these stories, for that is what they are, you will see yet again, for the photographer has seen it first, how the hands convey what our words, our facial expressions, sometimes cannot.

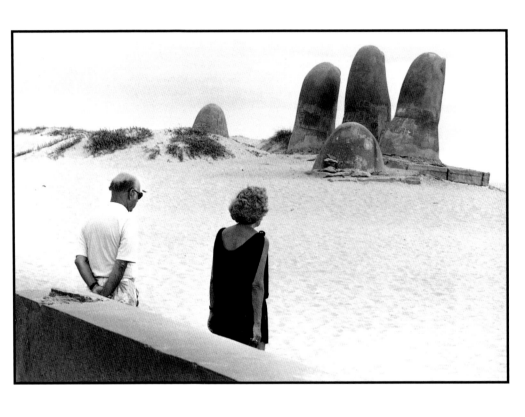

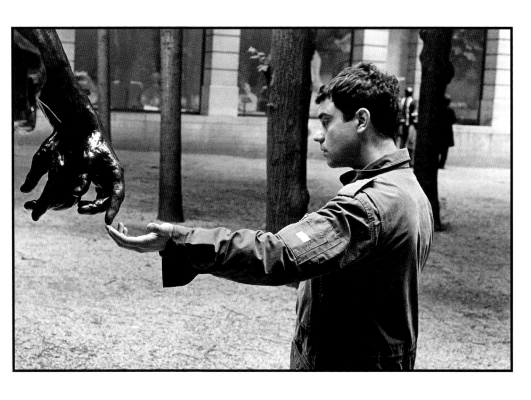

MUSÉE RODIN, PARIS, 1998

15

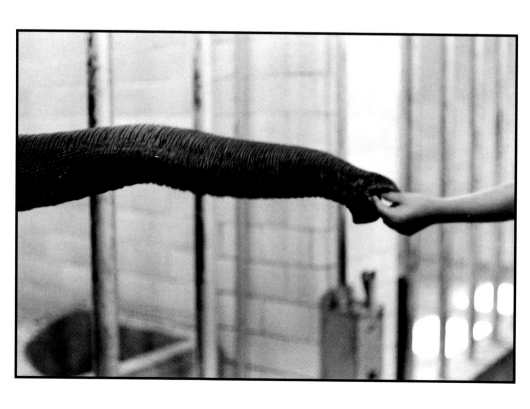

CENTRAL PARK ZOO, NEW YORK CITY, 1953

17

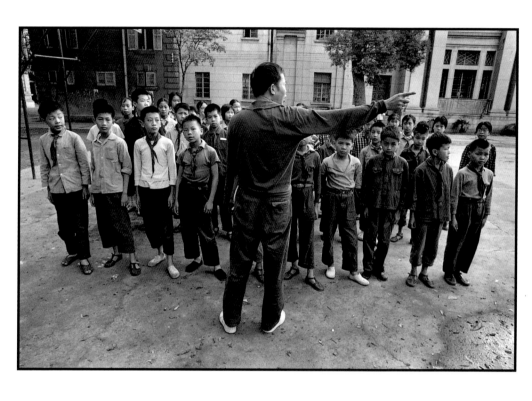

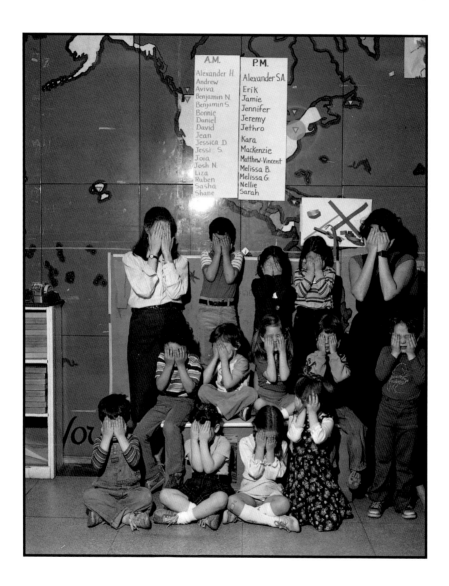

NEW YORK CITY, 1981

19

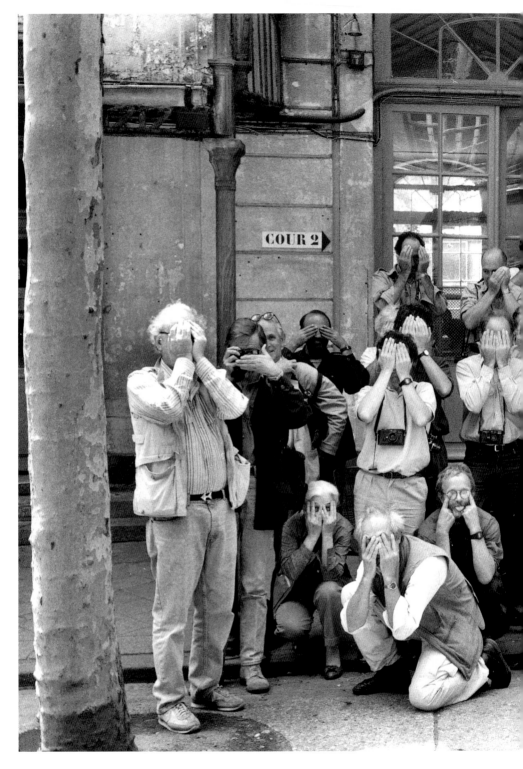

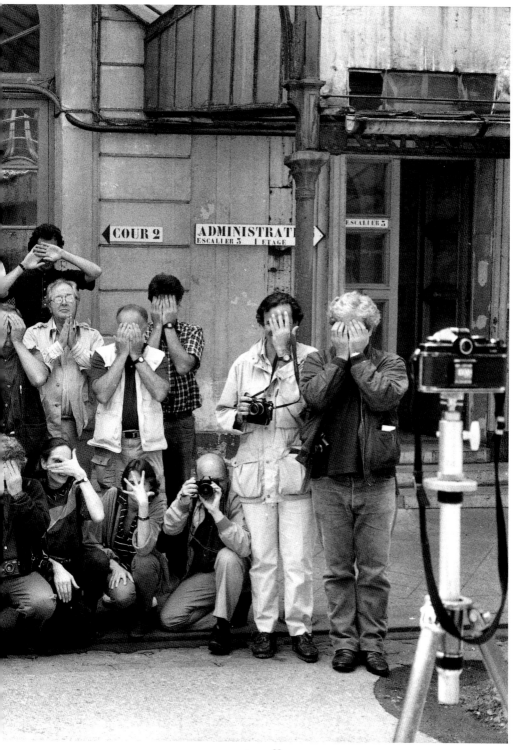

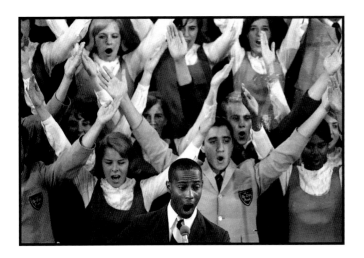

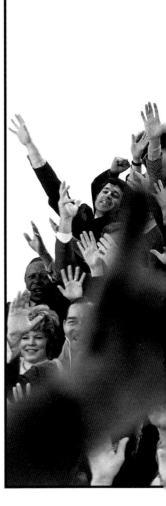

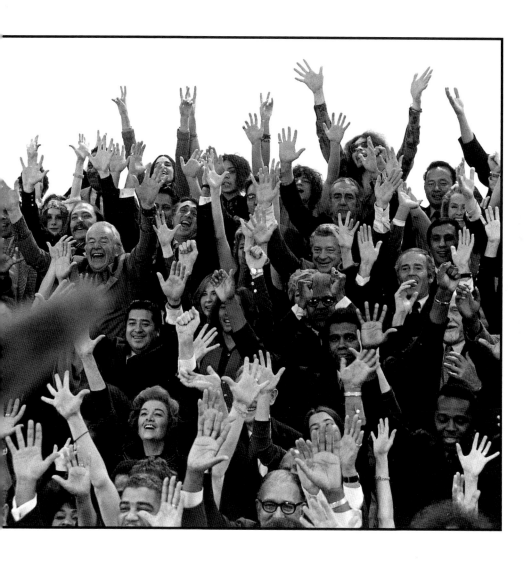

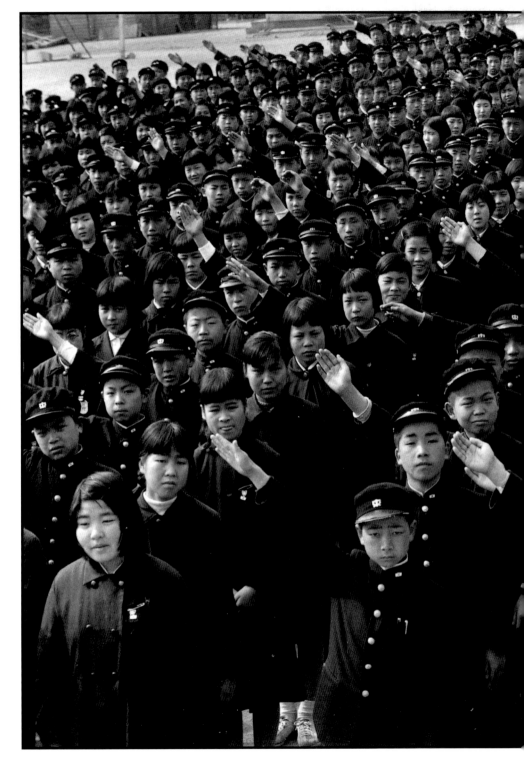

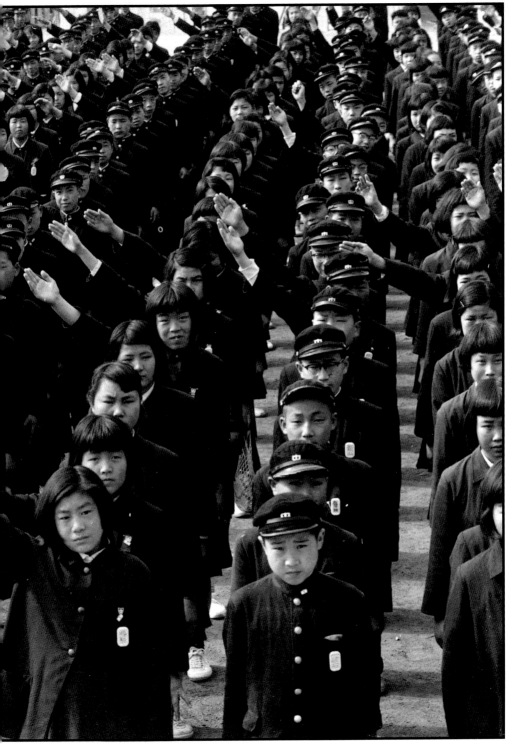

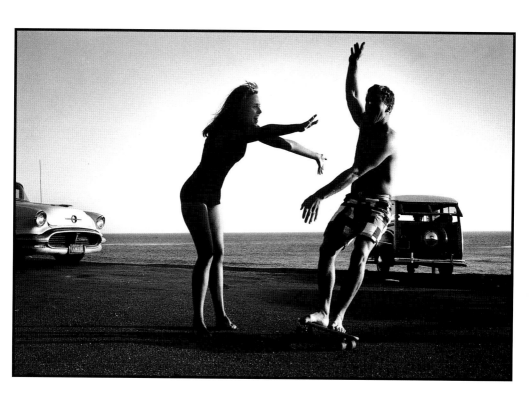

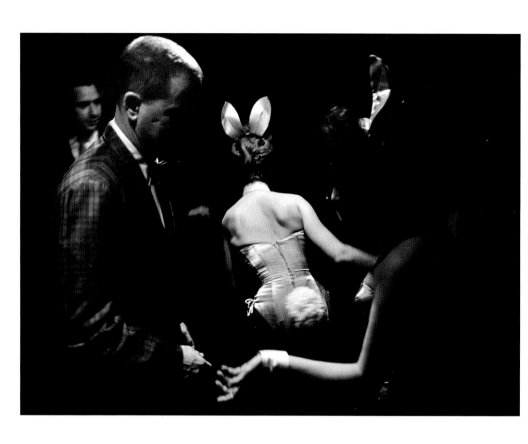

CHICAGO, PLAYBOY CLUB, 1962

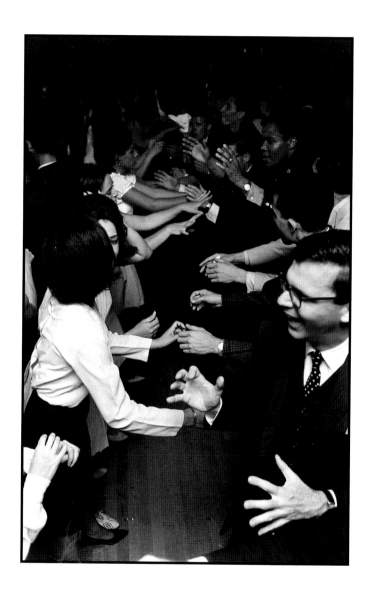

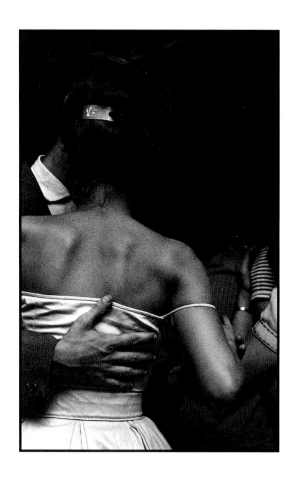

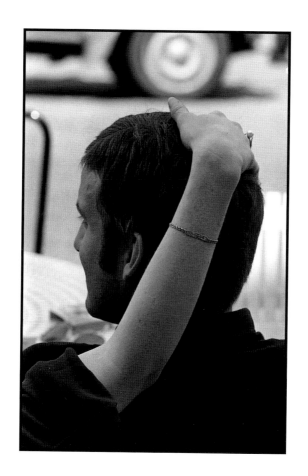

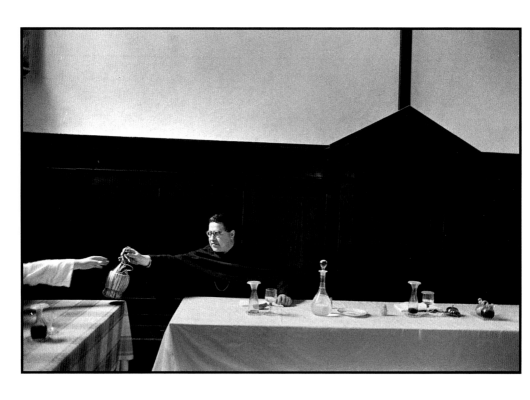

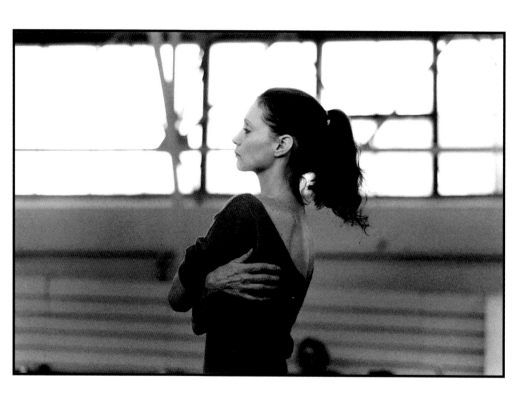

SUZANNE FARRELL, LENINGRAD, 1989

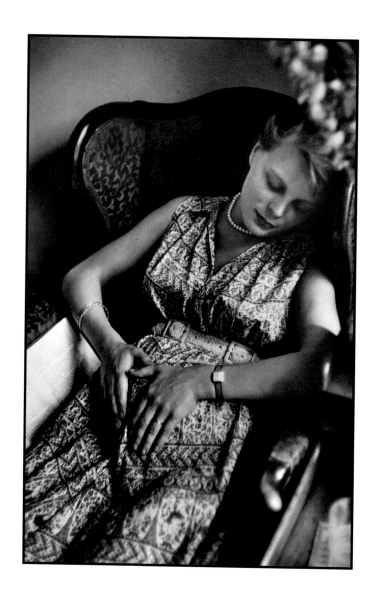

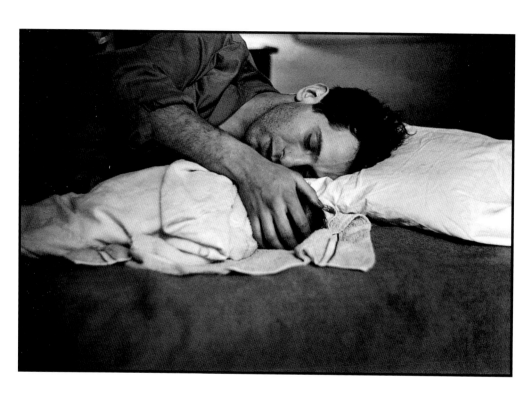

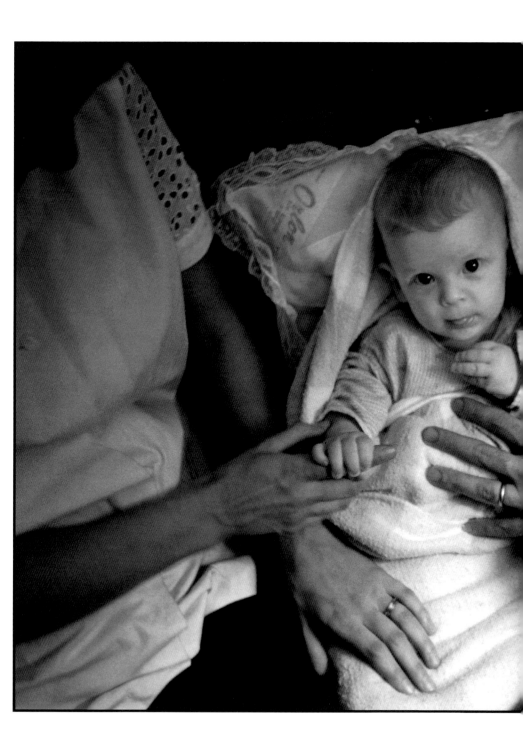

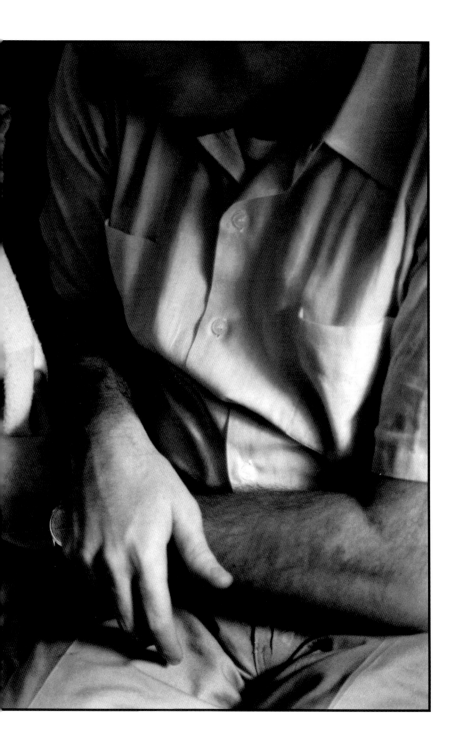

NEW ROCHELLE, NEW YORK, 1953

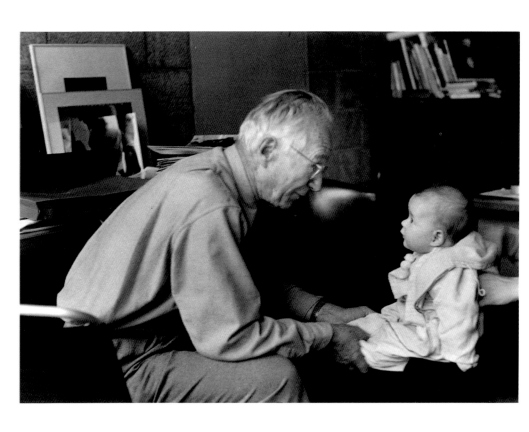

EDWARD STEICHEN AND ELLEN ERWITT, NEW YORK CITY, 1953

40

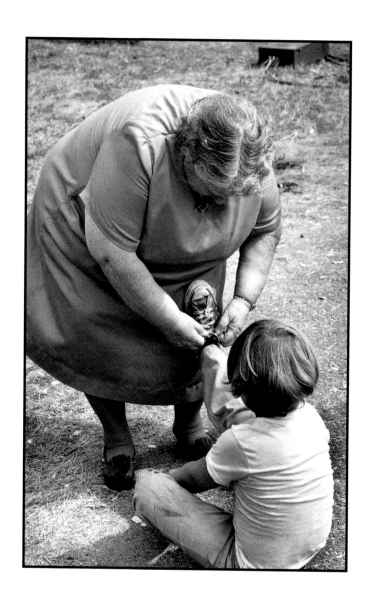

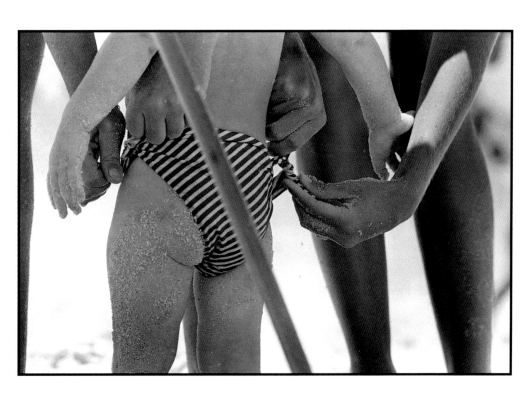

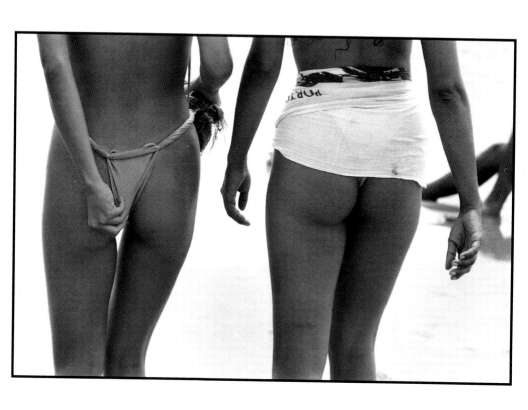

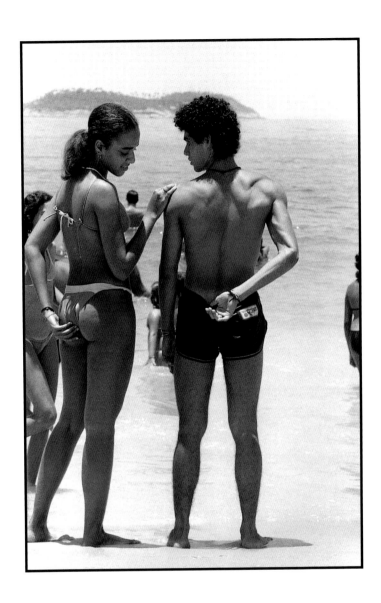

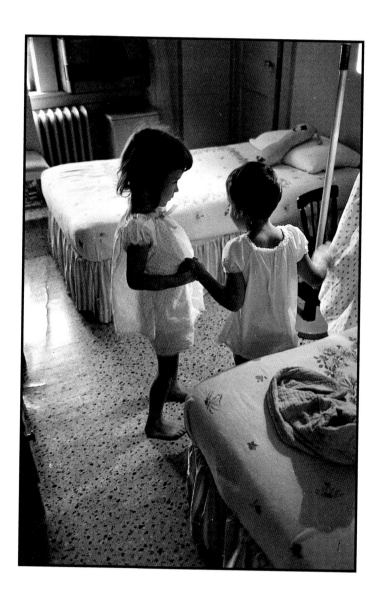

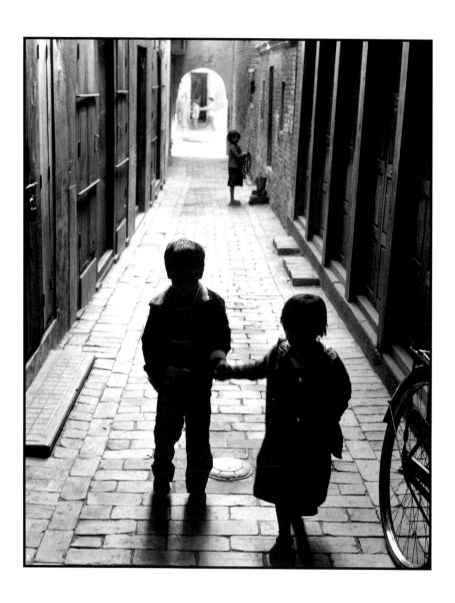

KATHMANDU, NEPAL, 1983

47

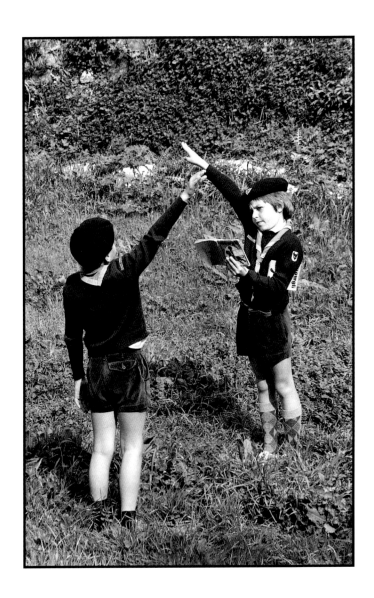

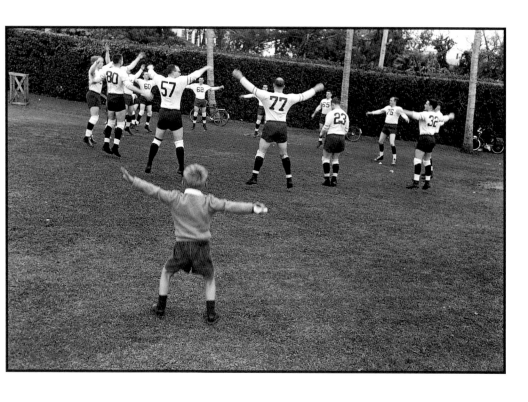

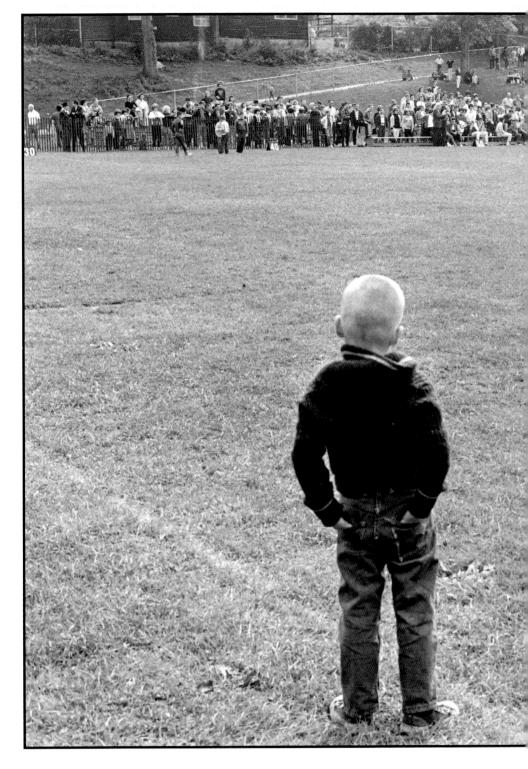

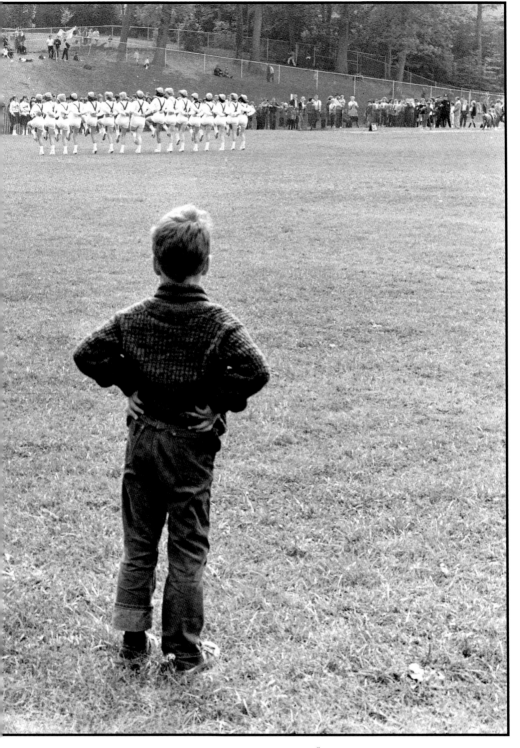

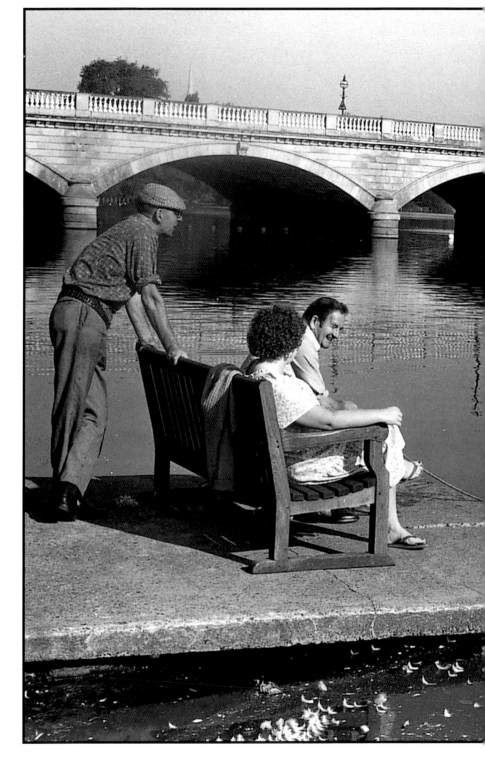

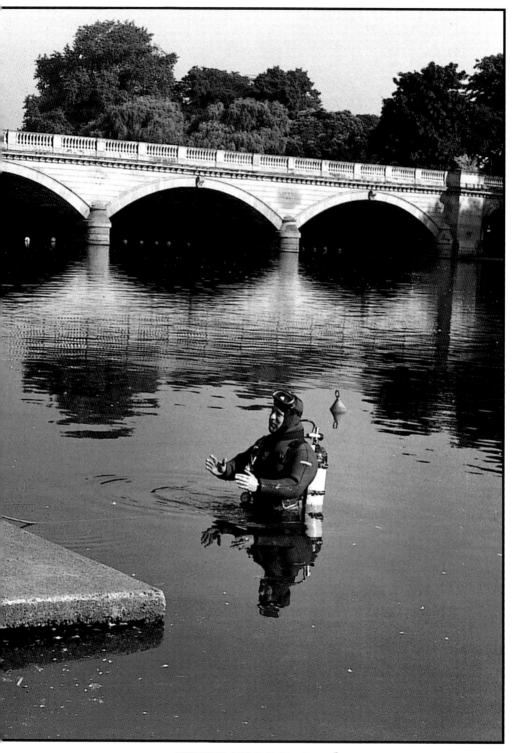

SERPENTINE, HYDE PARK, LONDON, 1978

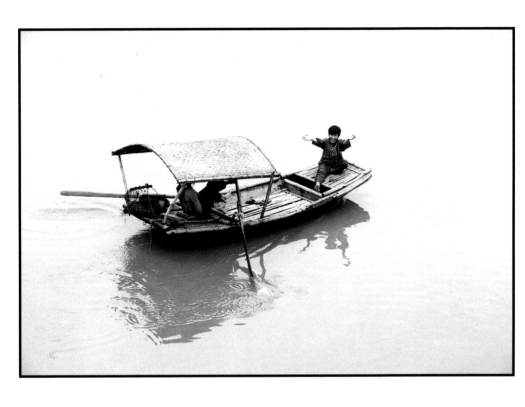

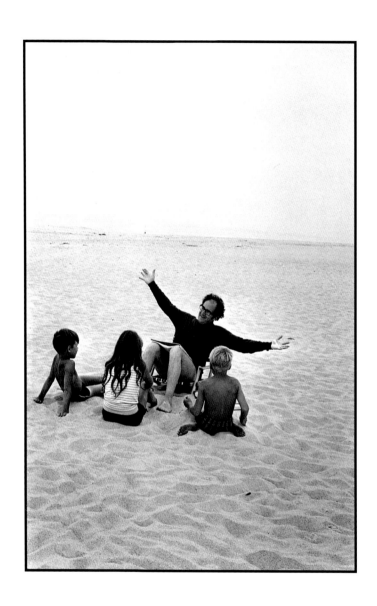

AMAGANSETT, NY, 1965

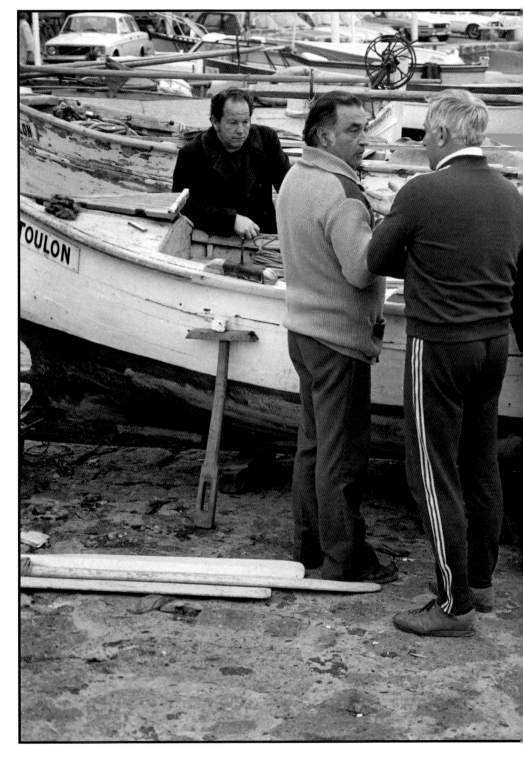

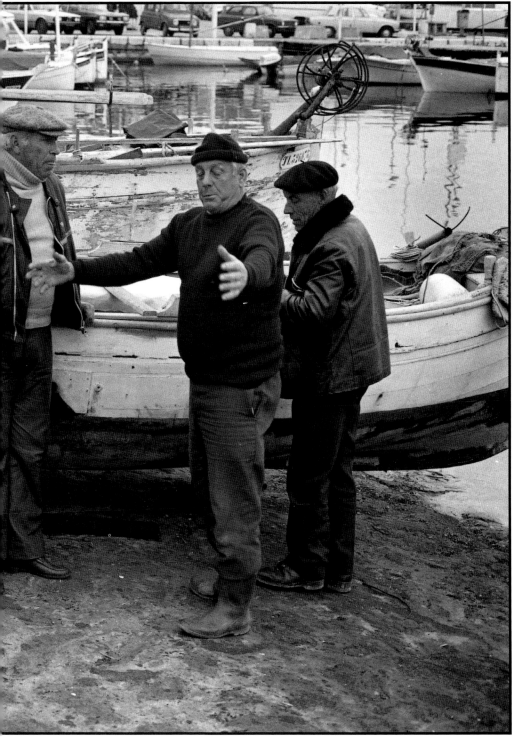

ST. TROPEZ, 1979

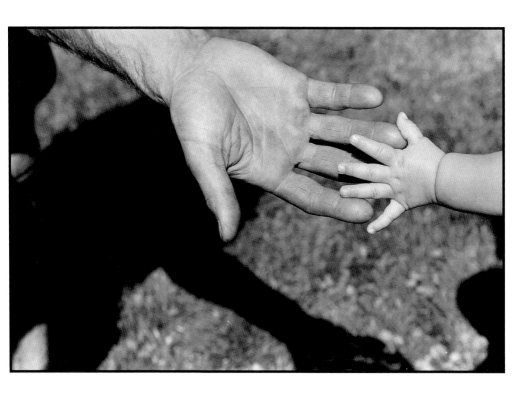

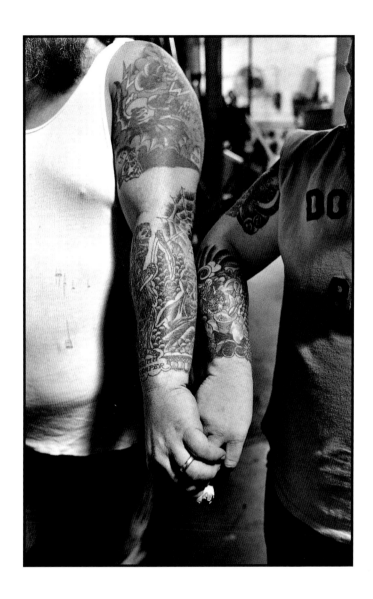

LOS ANGELES, 1978

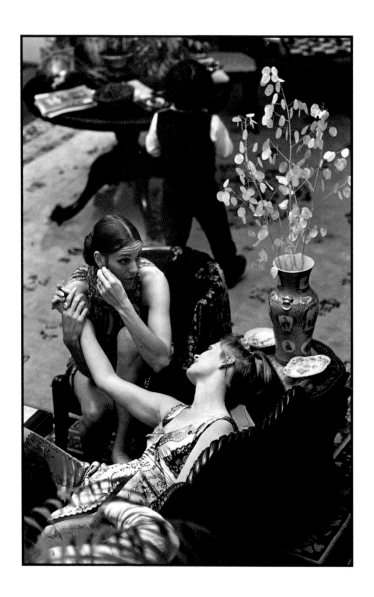

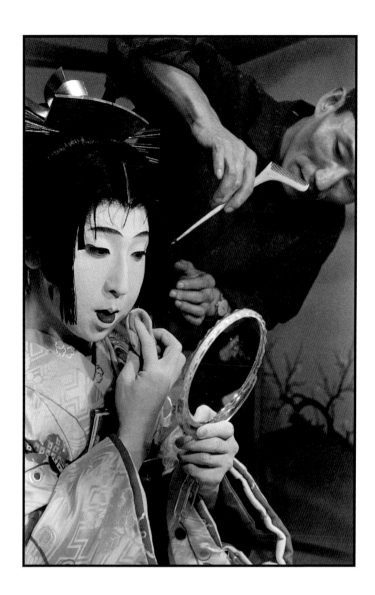

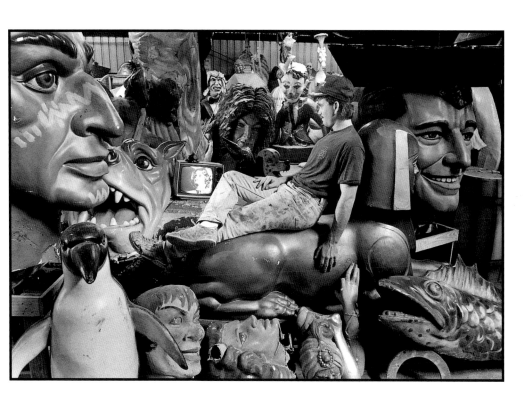

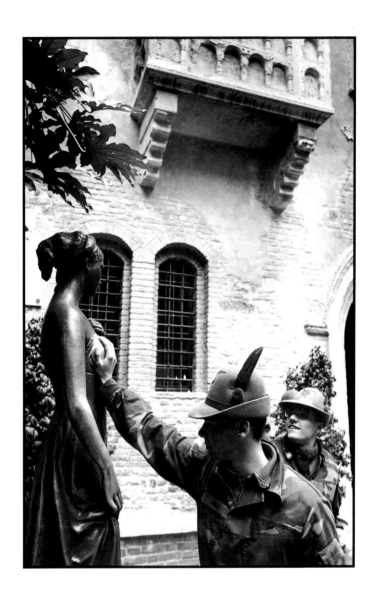

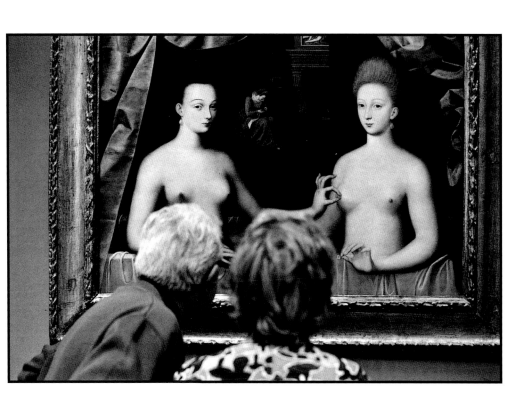

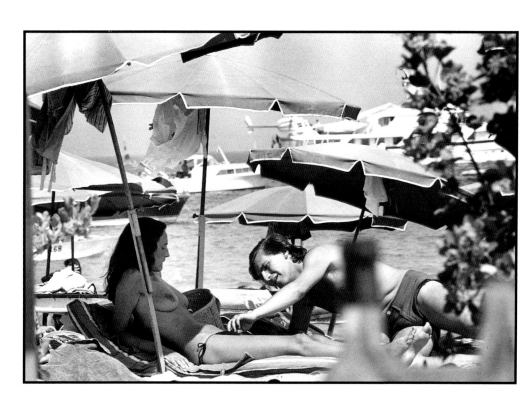

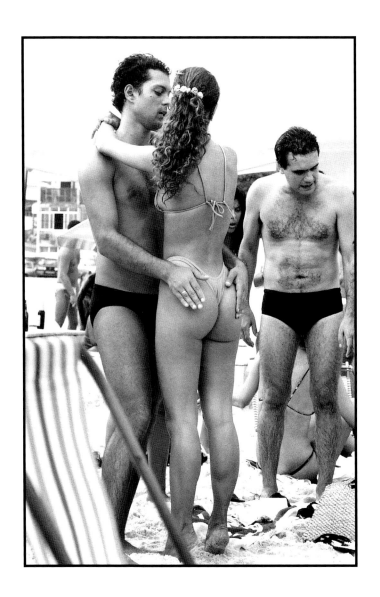

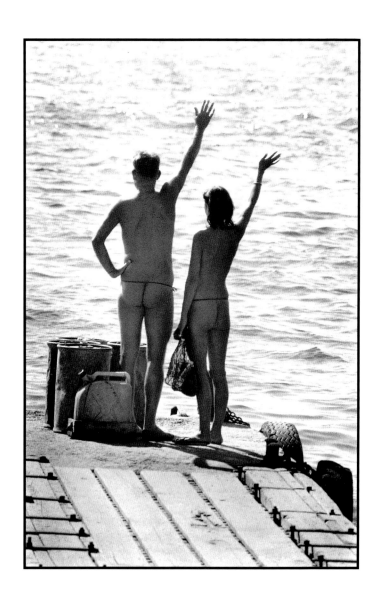

ILE DU LEVANT, FRANCE, 1968

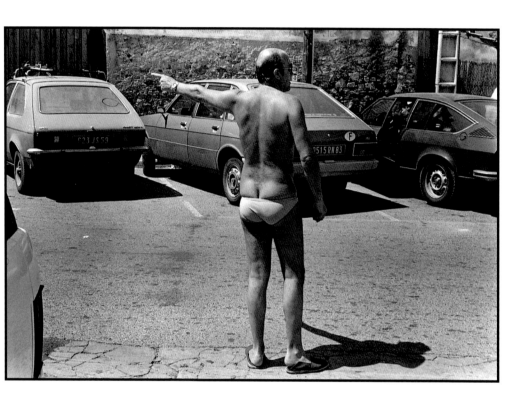

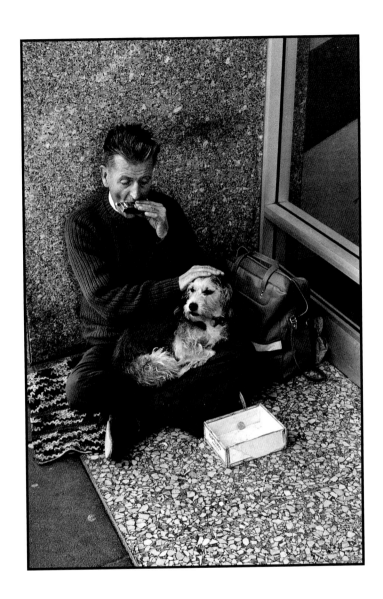

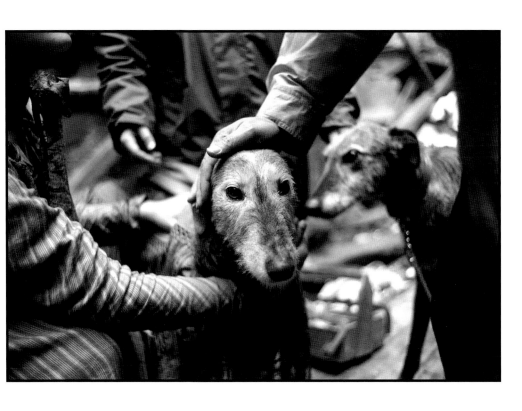

ALMEIRA, SPAIN, 1987

71

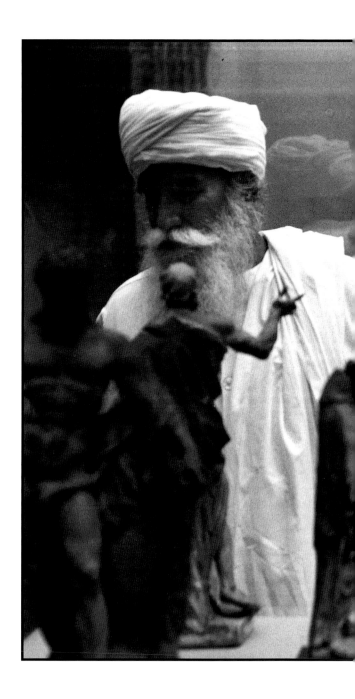

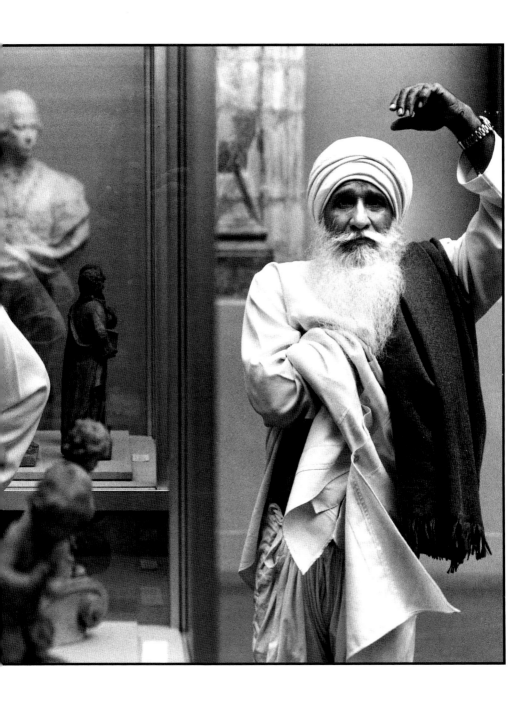

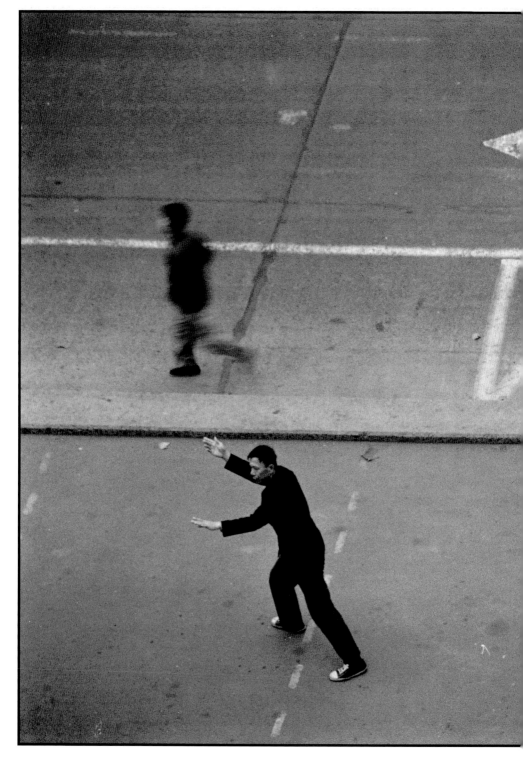

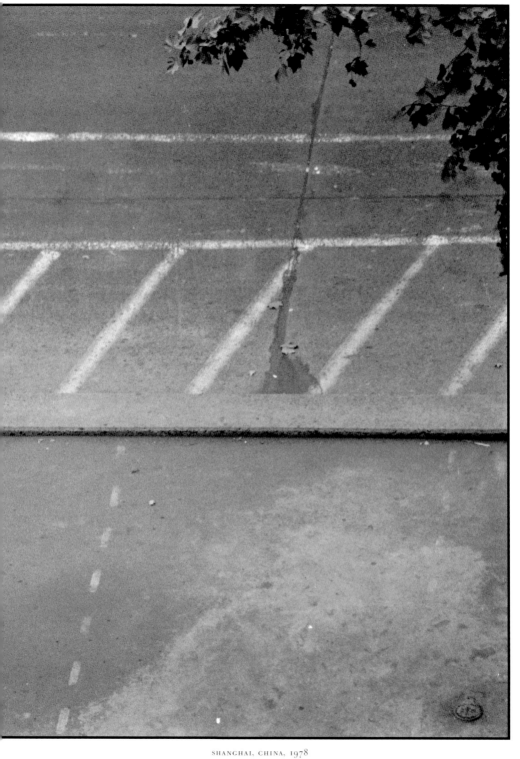

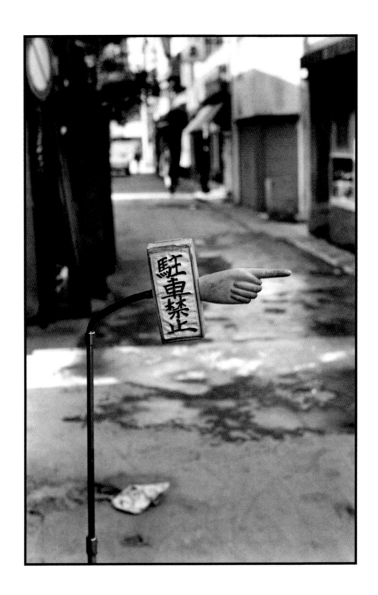

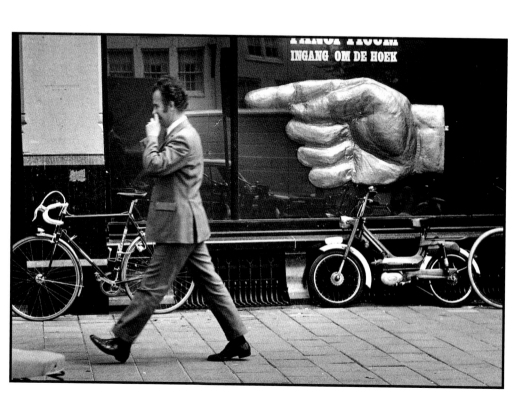

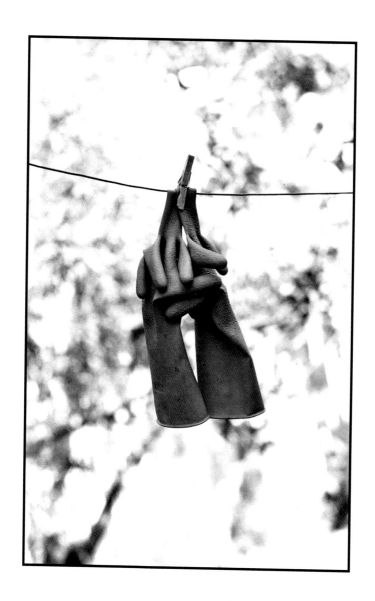

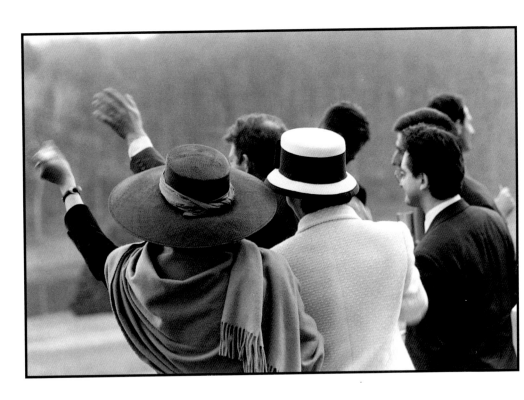

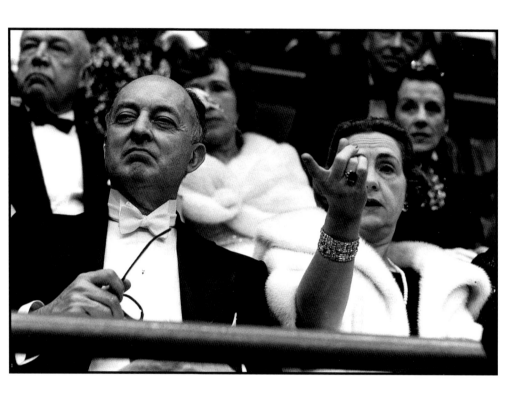

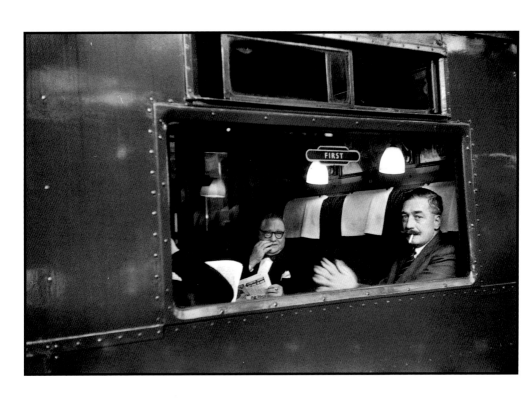

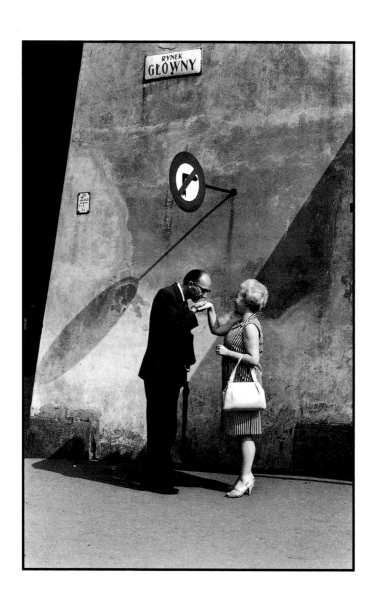

KRAKOW, POLAND, 1964

83

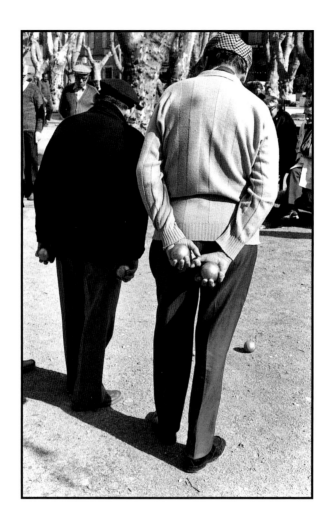

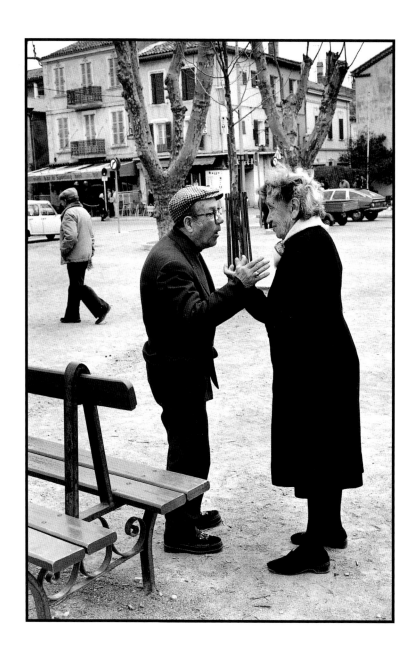

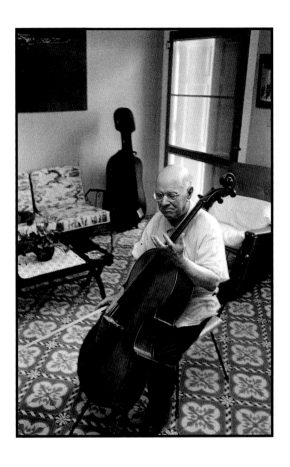

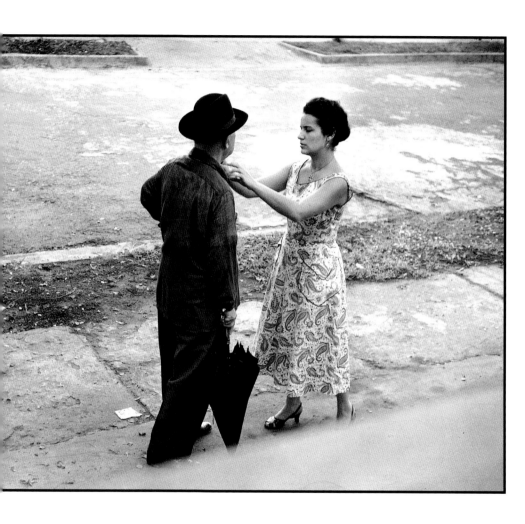

PABLO CASALS AND MARTINA, SAN JUAN, PUERTO RICO, 1957

87

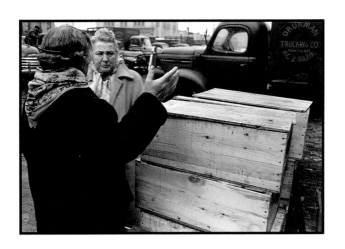

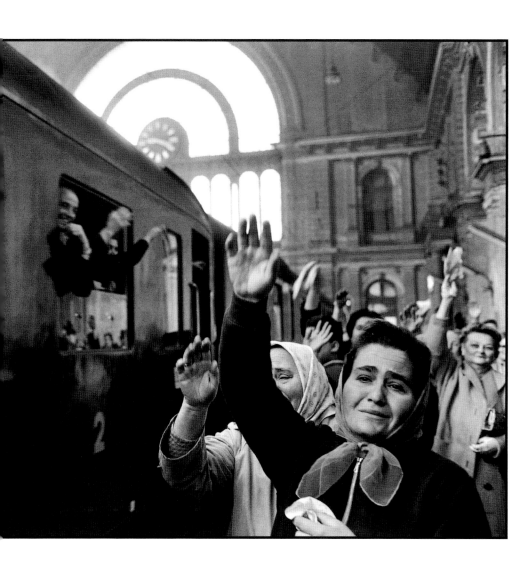

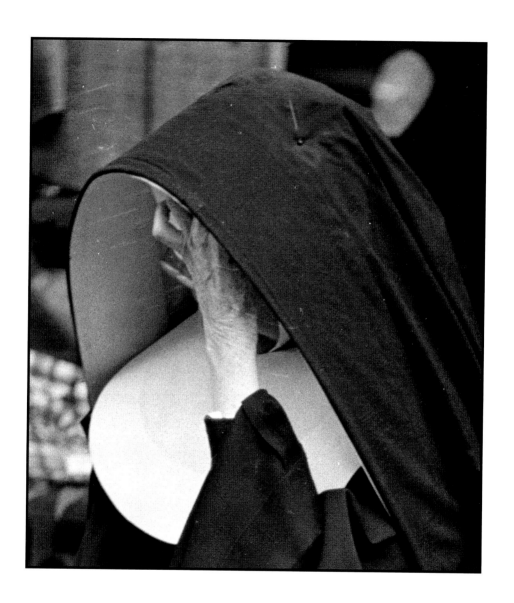

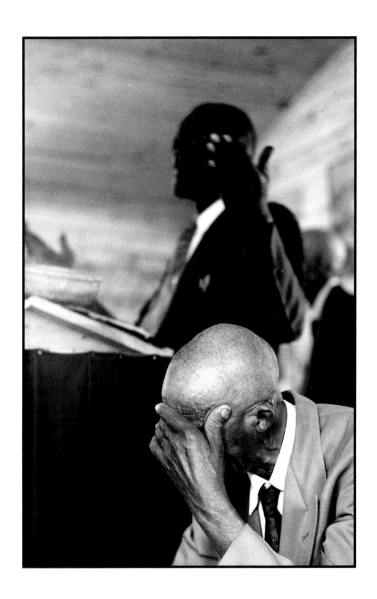

ARKADELPHIA, ALABAMA, 1954

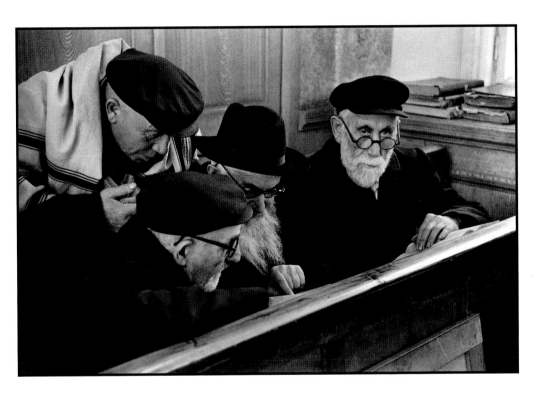

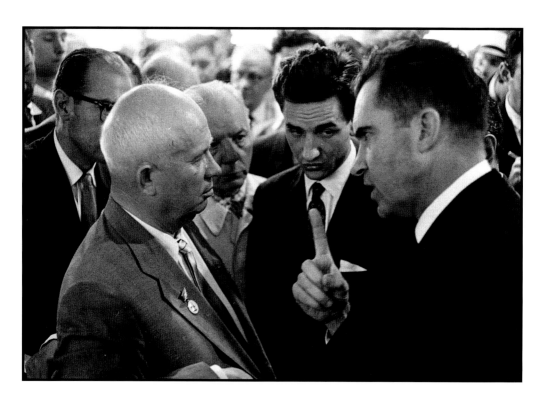

NIKITA KHRUSHCHEV AND RICHARD NIXON, MOSCOW, 1959

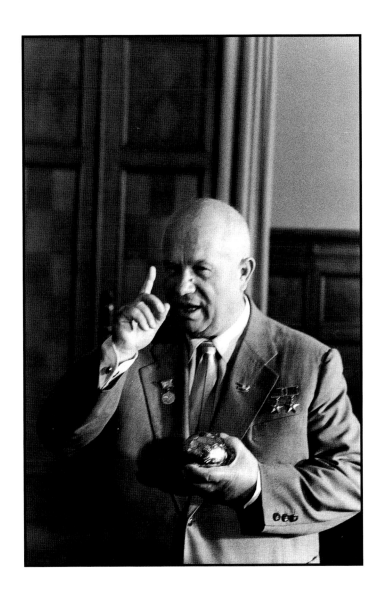

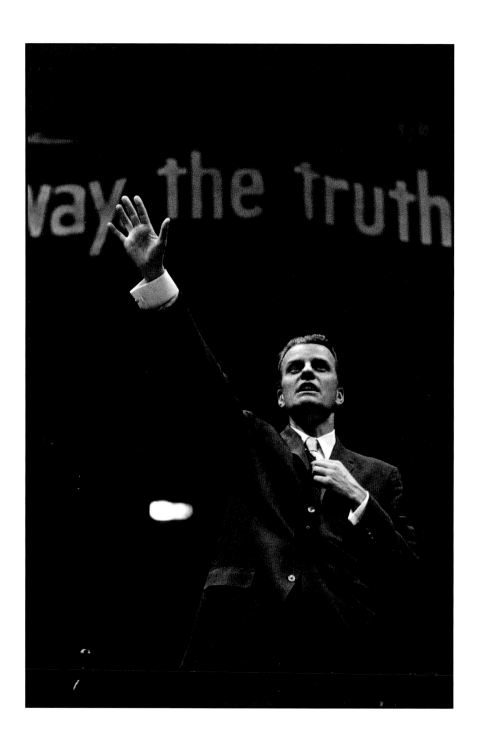

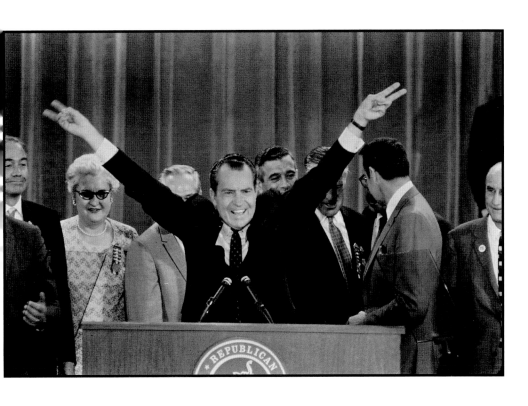

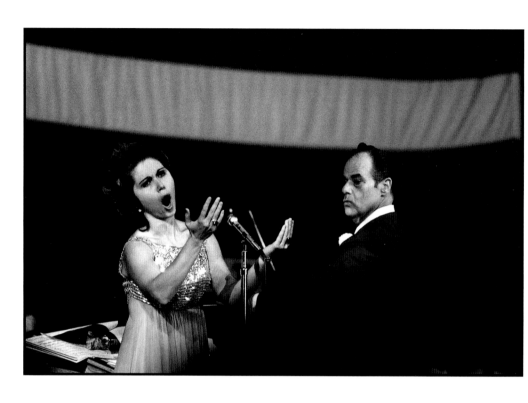

HENRY JACKSON, NEW YORK CITY, 1976

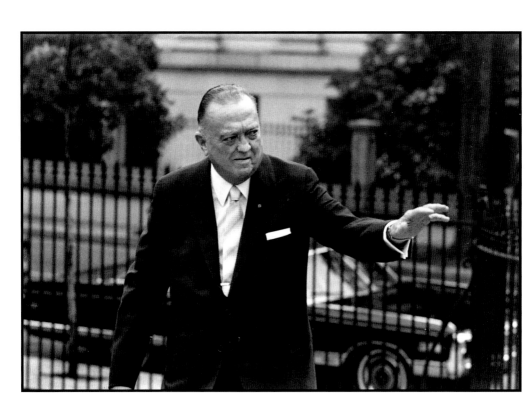

EDGAR J. HOOVER, WASHINGTON D.C., 1971

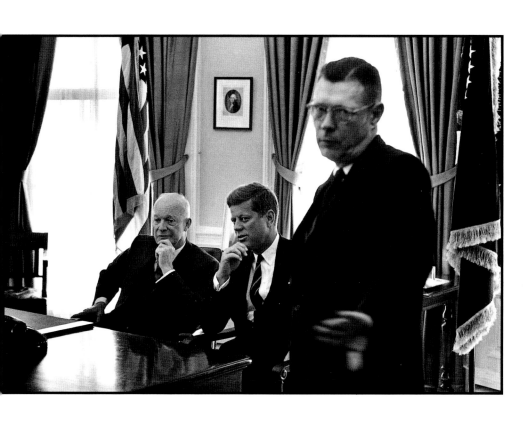

PRESIDENT EISENHOWER, JOHN F. KENNEDY, AND JAMES HAGERTY, WASHINGTON D.C., 1960

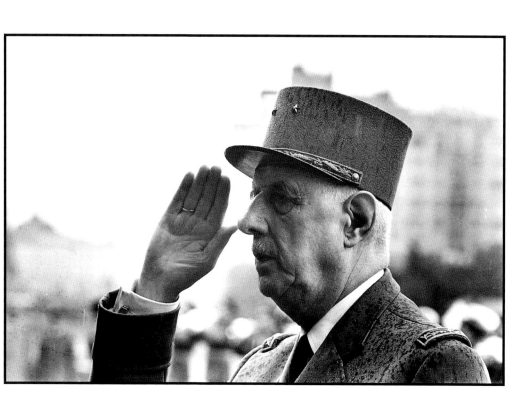

CHARLES DE GAULLE, LENINGRAD, 1966

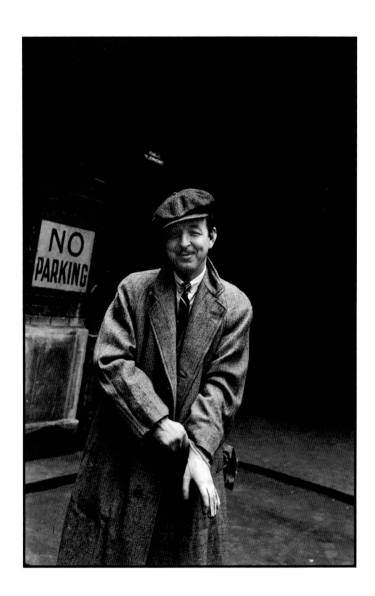

RANDALL JARELL, NEW YORK CITY, 1954

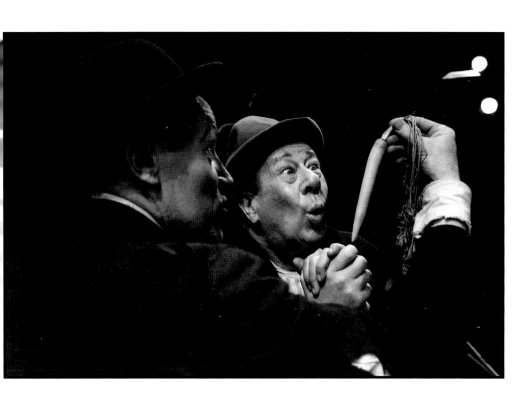

BERT LAHR AND E.G. MARSHALL, NEW YORK CITY, 1956

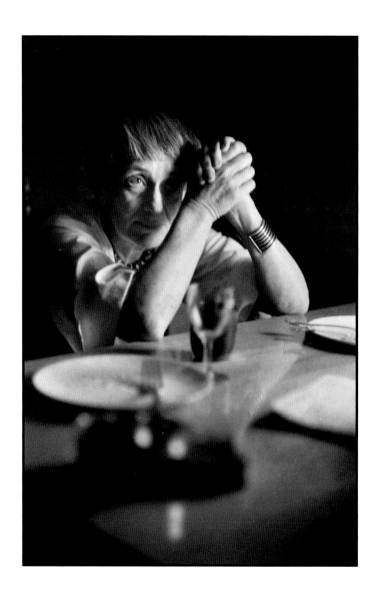

DOROTHEA LANGE, BERKELEY, CALIFORNIA, 1955

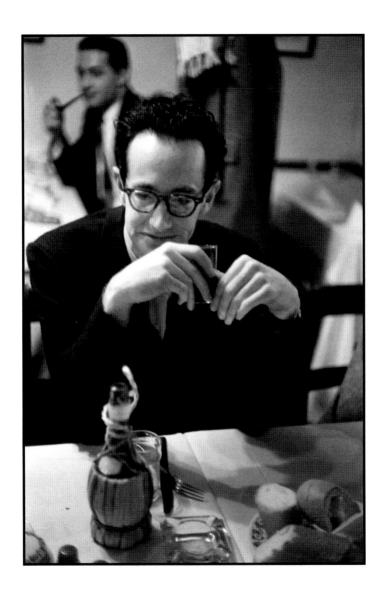

PAUL DESMOND, NEW YORK CITY, 1956

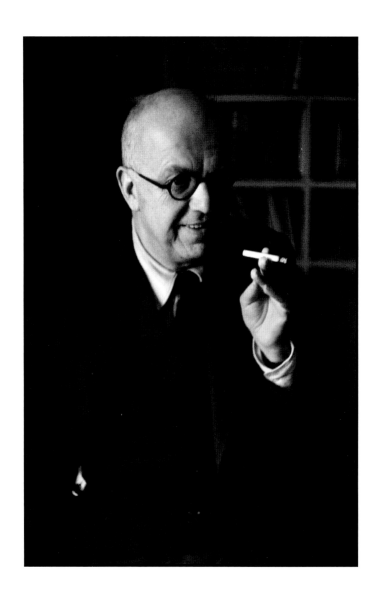

C. P. SNOW, LONDON, 1952

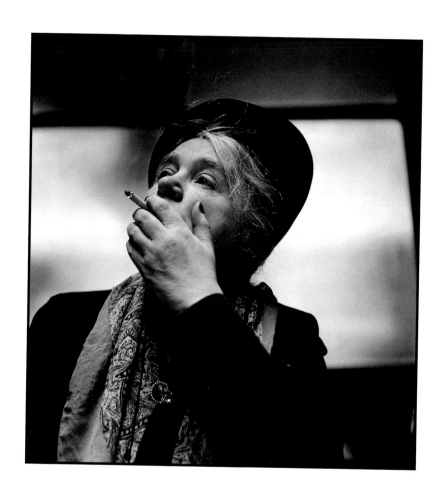

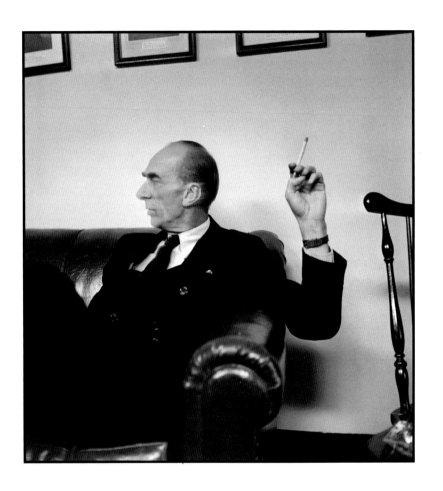

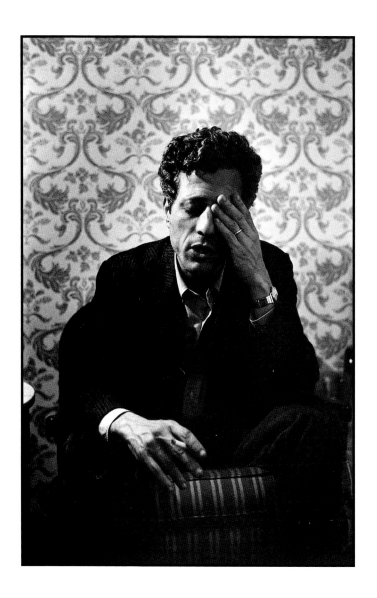

BERT MEYERS, NEW YORK CITY, 1966

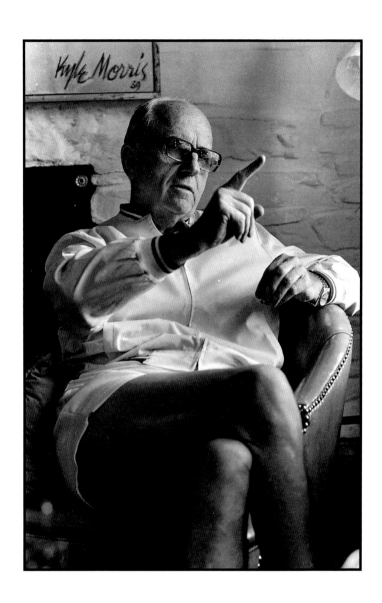

JAMES MICHENER, NEW YORK CITY, 1966

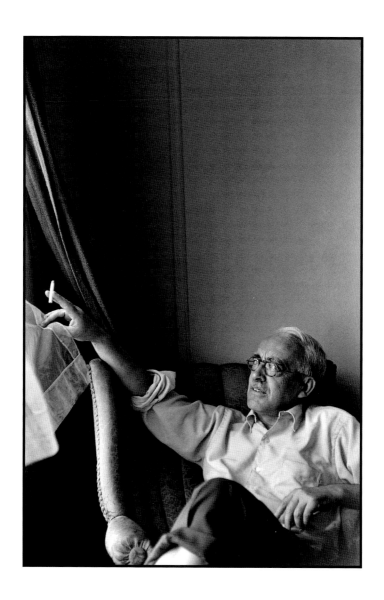

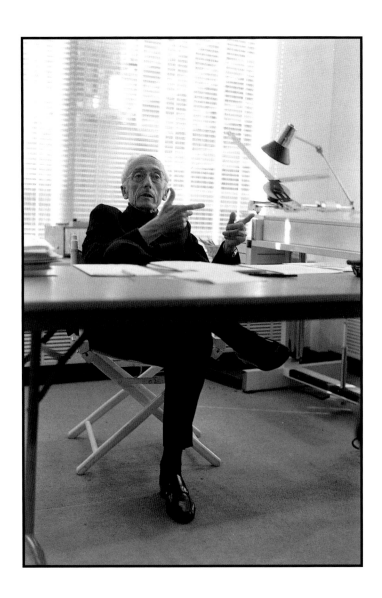

JACQUES COUSTEAU, NEW YORK CITY, 1978

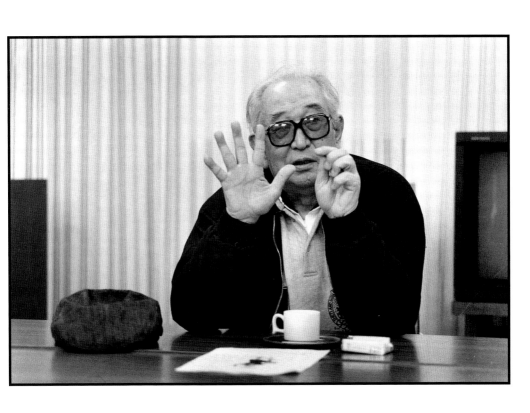

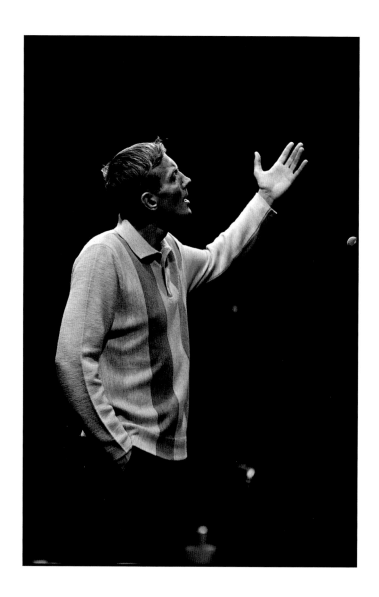

YEVGENY YEVTUSHENKO, 1966

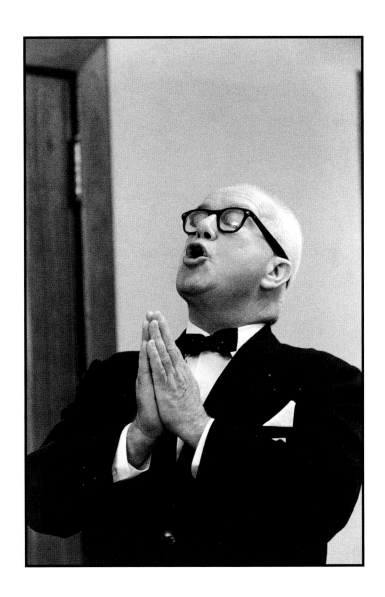

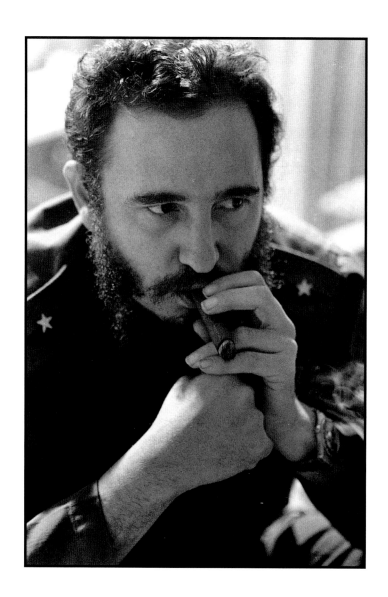

FIDEL CASTRO, HAVANA, 1964

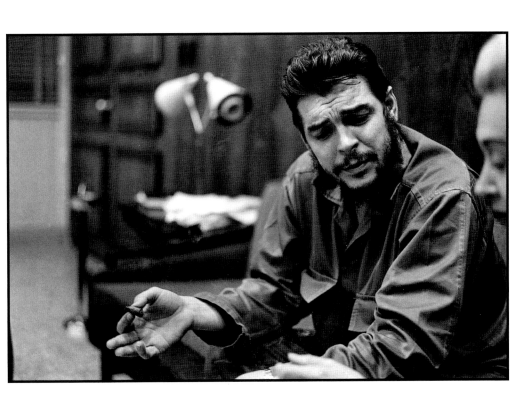

CHE GUEVARA, HAVANA, 1964

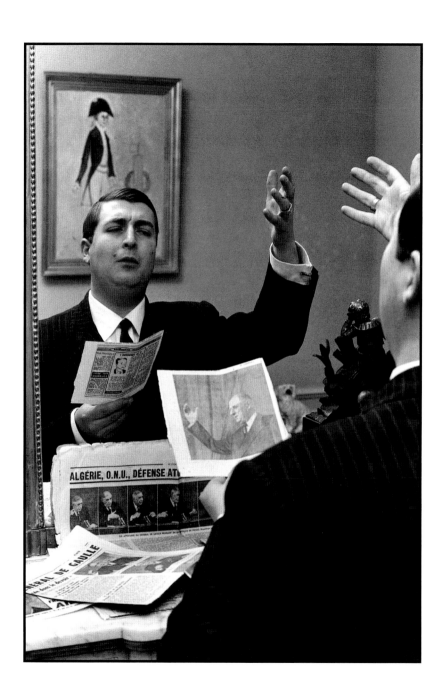

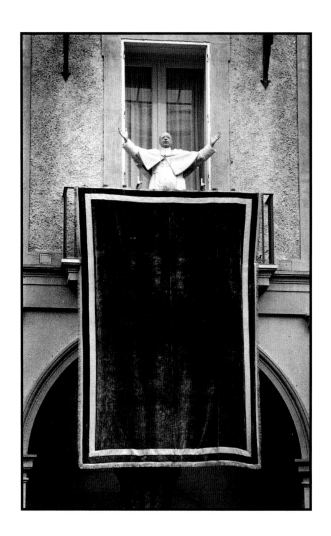

POPE PIUS XII, GANDOLFO, ITALY, 1957

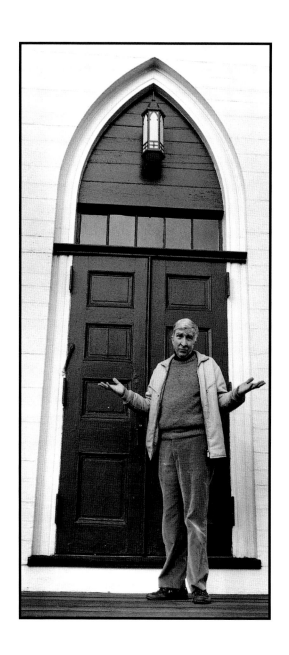

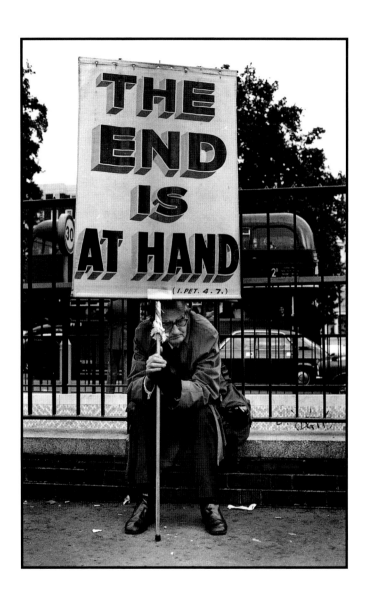

Afterword

When people ask me how I feel, I usually reply "with my hands and with my heart". Or when they ask, "How are you?" I answer "Reasonable," thus covering a lot of territory without saying anything in particular. It is one of my possibly annoying habits to avoid the banal "I'm fine, how are you?" retort, which I find totally unsatisfactory.

Prompted by the images in this book, I have looked into the matter of hands and heart and discovered that the heart has a more mechanical function, having to do with blood circulation, while the liver has a lot to do with the chemistry of one's emotions. Still, to answer "With my hands and with my liver" would not ring well.

Thinking even further, nothing negative surfaced about the pleasure that a caress or other emotionally charged hand gesture may give. So I am going to revise my answers. When asked how I feel, depending on who asks, my retort will be a gesture with hands apart, palms up and with a simultaneous shrug of the shoulders indicating things could be better; or I will simply say "None of your business," or just "Why don't you go out and buy this book?"

E.E.
East Hampton
19 July 2002

Thanks list

The usual suspects: my wife Pia, Jeff Ladd, Yayoi Sawada, Charles Flowers, Katy Homans, Jim Mairs, and my agency, Magnum Photos.

None of the pictures in this book have been digitally altered or manipulated.